DRAWING
TREES

VICTOR PERARD

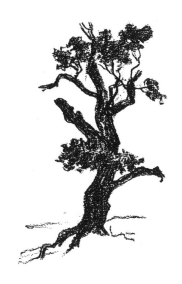

DOVER PUBLICATIONS, INC.
MINEOLA, NEW YORK

Bibliographical Note

This Dover edition, first published in 2007, is an unabridged republication of the work originally published in 1955 by the Pitman Publishing Corporation, New York.

Library of Congress Cataloging-in-Publication Data

Perard, Victor Semon, 1870–1957.
 Drawing trees / Victor Perard.
 p. cm.
 Originally published: Pitman Publishing Corporation, 1955.
 ISBN-13: 978-0-486-46034-5 (pbk.)
 ISBN-10: 0-486-46034-7 (pbk.)
 1. Trees in art. 2. Landscape drawing. I. Title.

NC810.P4 2007
743'.76—dc22

2007008310

Manufactured in the United States by Courier Corporation
46034707 2015
www.doverpublications.com

FIRST OF ALL

Art is the finest way of doing anything. Pencil drawing is one of the fine arts, and one of the easiest to master. It will repay the student ten-fold for the amount of effort expended. It is important to have the right materials to work with.

In landscape drawing it is advisable to use a medium pencil H.B., a soft one B.B.B. and a soft eraser.

Art materials should be treated with respect and pencils used deftly, varying the pressure to obtain dark and light tones.

Drawings should be neat and of a professional appearance. The outline should be dwelt on before starting to shade. The shadows are used to give depth and thickness and by varying their tints, roundness is obtained.

The proper placing of a sketch on the paper is important and requires judgment and a sense of composition which are a part of the art training. A drawing badly placed on the paper loses value.

As a help in placing the contemplated drawing on the paper, sketch with your finger on the paper an imaginary outline of the subject and at the same time try to visualize the completed picture.

After this, use the H.B. pencil very lightly to draw the essential lines of the subject selected. Heavy black lines used too soon may kill the vision of the picture and thus impress mistakes on the mind.

After becoming proficient in copying drawings try to make compositions of your own.

Practice drawing from nature. Be careful to select simple subjects. Better a simple subject well done than a difficult one poorly rendered.

After copying some simple subject in this book try drawing it from memory. This is excellent practice and will help to recall effects too rapid and transient to sketch, yet most valuable as data for future reference.

With proper training there should be no waiting for inspiration. Make preliminary sketches and memory sketches until you force inspiration.

Further Suggestions

Before touching pencil to paper, hold yourself in check until you try to visualize clearly the drawing you intend to make and the pencil technique you plan to use.

The first lines should be the most important and the last ones of least value.

Training the eye and hand to co-ordinate, gives quite a thrill when mastered. The problems are different in every picture, which makes for one of the fascinating aspects of the study of art. The feeling for art goes to waste unless backed by knowledge with which to work.

To draw form correctly is less a natural ability than the result of acquired training. Most gifted students lack the patience to study and try stunts to escape work, thus enabling students with less natural facility and more method and application to out-class them.

Without order and method the work is uneven in quality, good one day, bad the next.

A drawing to have charm must be made with poise.

In hurried work knowledge may be given out but little absorbed.

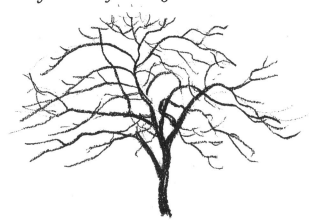

Shading Technique

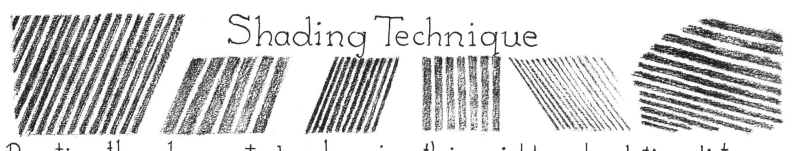

Practice the above strokes keeping their weight and relative distances. Whether you are right-or left-handed, this will prove excellent practice for future work, and give co-ordination between hand and eye.

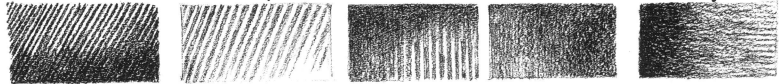

Now keep your lines closer together melting them into flat tints and graded ones, as illustrated above.
Practice this shading until proficient in control of the pencil and its pressure thus varying the required tints.

Sharpen the lead of a BBB pencil to resemble a chisel and wear down the lead smooth for broad strokes. The pencil will then prove practical and effective for sketching. It will help to vary the width of strokes, thus lending interest to the drawing.

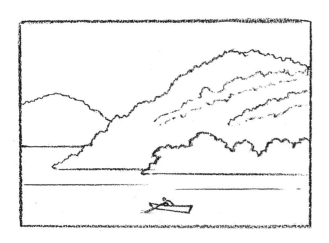

Fundamental Outline

The first and all-important concern of the artist is to see the forms before him in simple outline at first, avoiding interest in detail.

This method should be closely adhered to in future work.

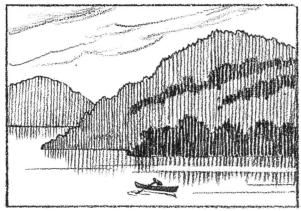

To shade distant landscapes with vertical strokes gives solidity, keeps the mountains in simple masses. The distant mountain is silhouetted and shows no detail except for a slight broken line to indicate trees on the mountain top.

The same broken line is used on the nearer mountain, but with more detail and the nearer mountain is shaded to suggest that it is covered with trees in the distance, middle distance and foreground.

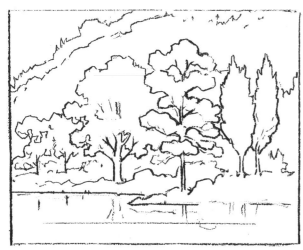

The group of trees on the right is nearer and so begins to show the shape of the shadows made by the foliage. These should be mapped out and seen as a pattern giving a feeling of design.

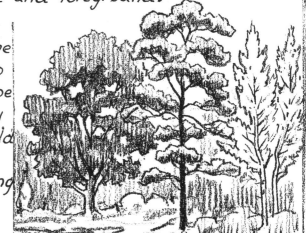

In getting closer to the white pine its detail is more apparent, showing the trunk and branching, the foliage grouped in masses and the <u>shapes</u> <u>of</u> <u>the</u> <u>shadows</u>. For drawing these, it is best to use the B.B.B. pencil sharpened for broad strokes.

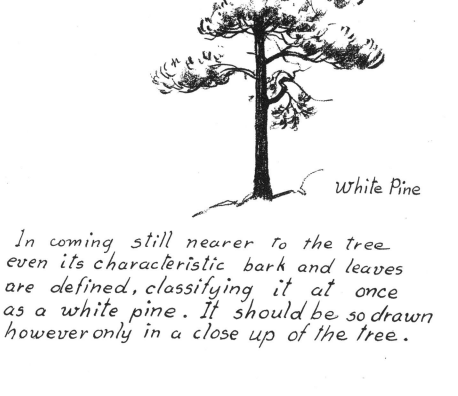

White Pine

In coming still nearer to the tree even its characteristic bark and leaves are defined, classifying it at once as a white pine. It should be so drawn however only in a close up of the tree.

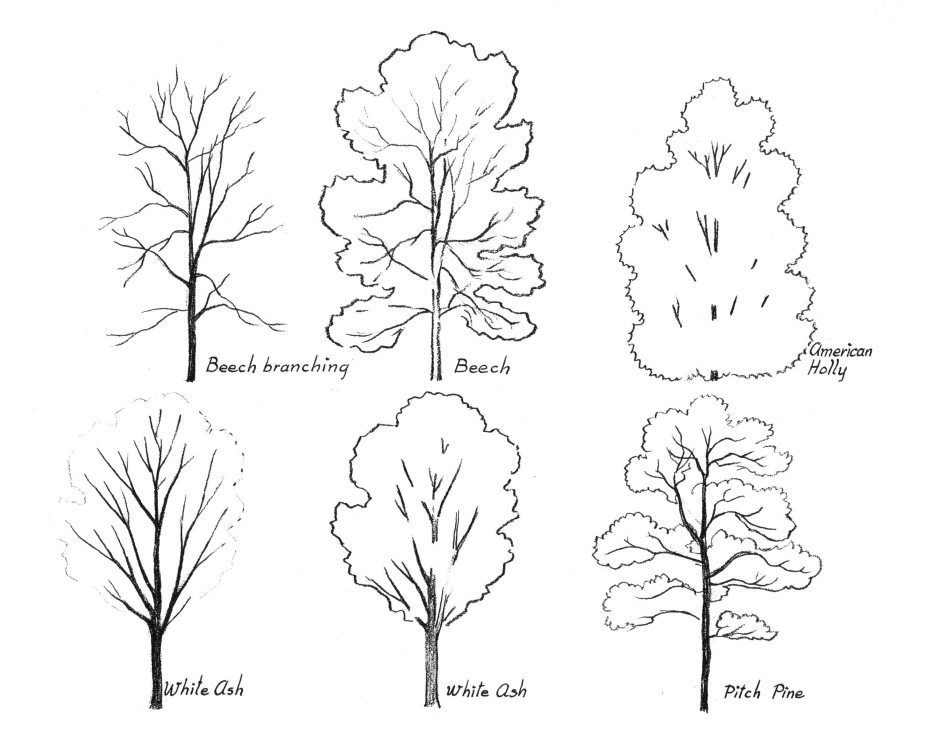

Beech branching

Beech

American Holly

White Ash

White Ash

Pitch Pine

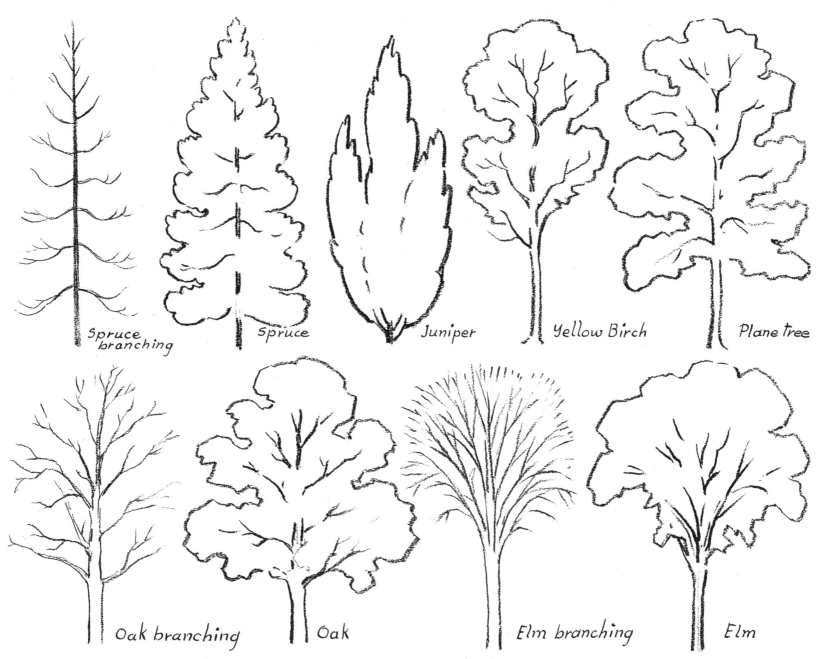

Spruce branching Spruce Juniper Yellow Birch Plane tree

Oak branching Oak Elm branching Elm

Draw simple forms of trees, to get acquainted with their characteristics. When the trees are reduced to basic lines, their individual types are more clearly brought out.

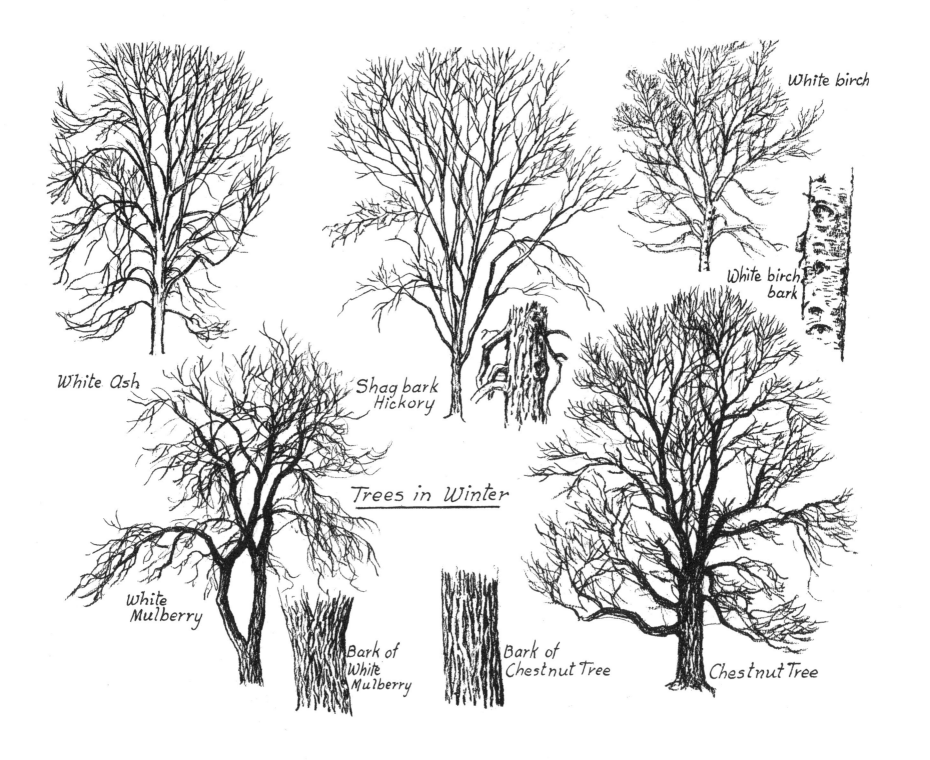

White birch

White birch bark

White Ash

Shagbark Hickory

White Mulberry

Bark of White Mulberry

Trees in Winter

Bark of Chestnut Tree

Chestnut Tree

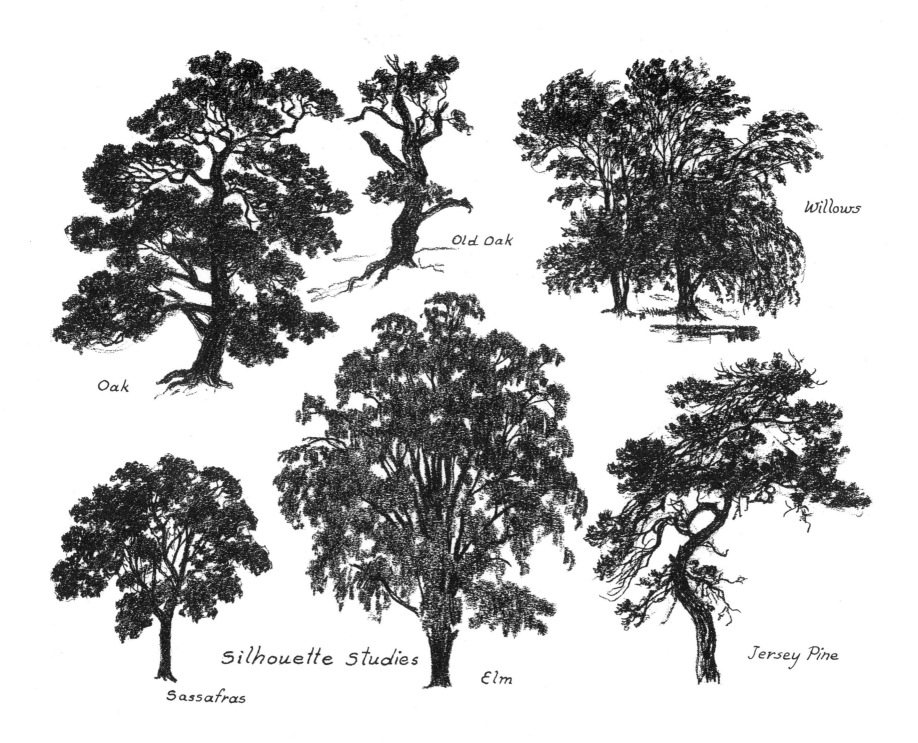

Old Oak

Willows

Oak

Silhouette Studies

Sassafras

Elm

Jersey Pine

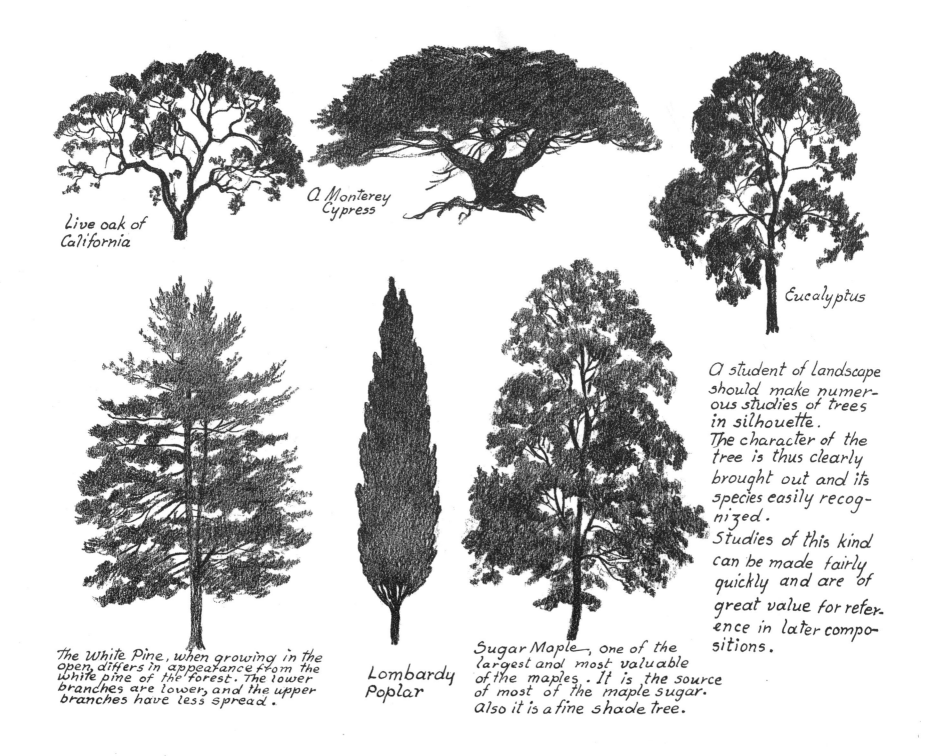

Live oak of
California

A Monterey
Cypress

Eucalyptus

The White Pine, when growing in the
open, differs in appearance from the
white pine of the forest. The lower
branches are lower, and the upper
branches have less spread.

Lombardy
Poplar

Sugar Maple, one of the
largest and most valuable
of the maples. It is the source
of most of the maple sugar.
Also it is a fine shade tree.

A student of landscape
should make numer-
ous studies of trees
in silhouette.
The character of the
tree is thus clearly
brought out and its
species easily recog-
nized.
Studies of this kind
can be made fairly
quickly and are of
great value for refer-
ence in later compo-
sitions.

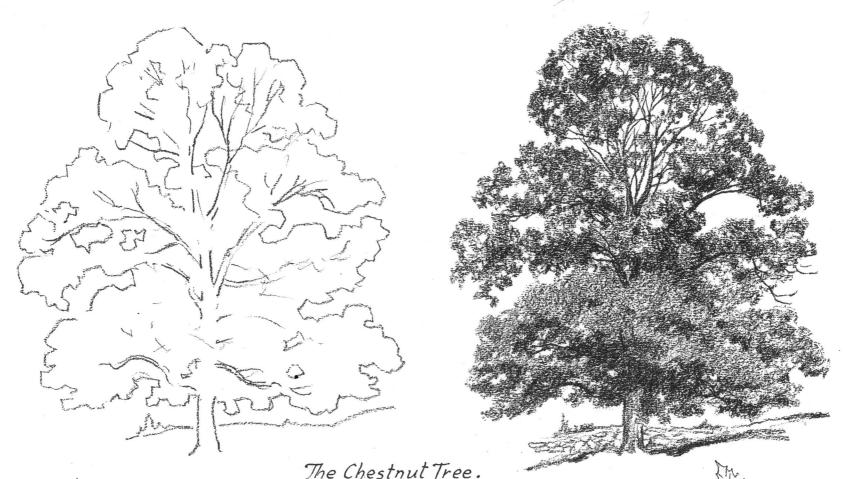

The Chestnut Tree.

Bark

Leaf

Draw the masses in outline as illustrated above. Then lighten the lines by tapping with a rubber, and go over the drawing again, giving a more delicate grouping of the foliage.
After being certain of the characteristics of the chestnut tree, start to shade, using the shapes of shadows to group the masses of foliage. On another page is shown a drawing of a chestnut tree and its branches as seen in winter. This should be studied at the same time.
The American chestnut is one of our most beautiful trees. It is symmetrical in form, with low spreading branches. It blossoms in July, and in the autumn the leaves turn a fine yellow.
It is found from Maine to southern Delaware and to the Mississippi.

Nuts in open burr

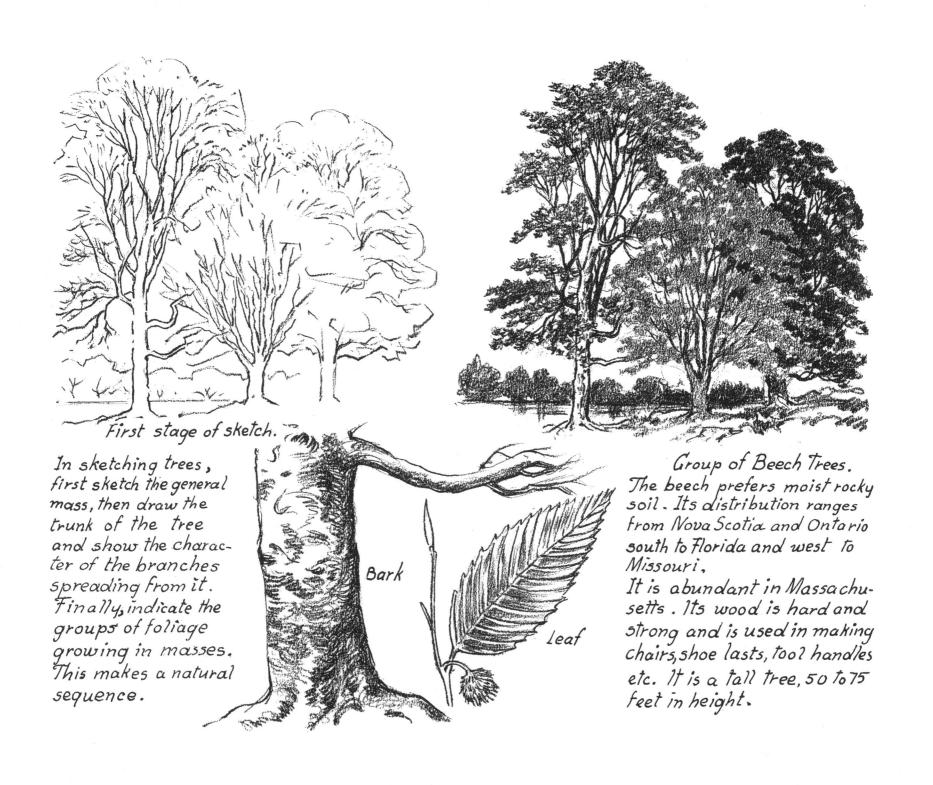

First stage of sketch.

In sketching trees, first sketch the general mass, then draw the trunk of the tree and show the character of the branches spreading from it. Finally, indicate the groups of foliage growing in masses. This makes a natural sequence.

Bark

Leaf

Group of Beech Trees.

The beech prefers moist rocky soil. Its distribution ranges from Nova Scotia and Ontario south to Florida and west to Missouri.

It is abundant in Massachusetts. Its wood is hard and strong and is used in making chairs, shoe lasts, tool handles etc. It is a tall tree, 50 to 75 feet in height.

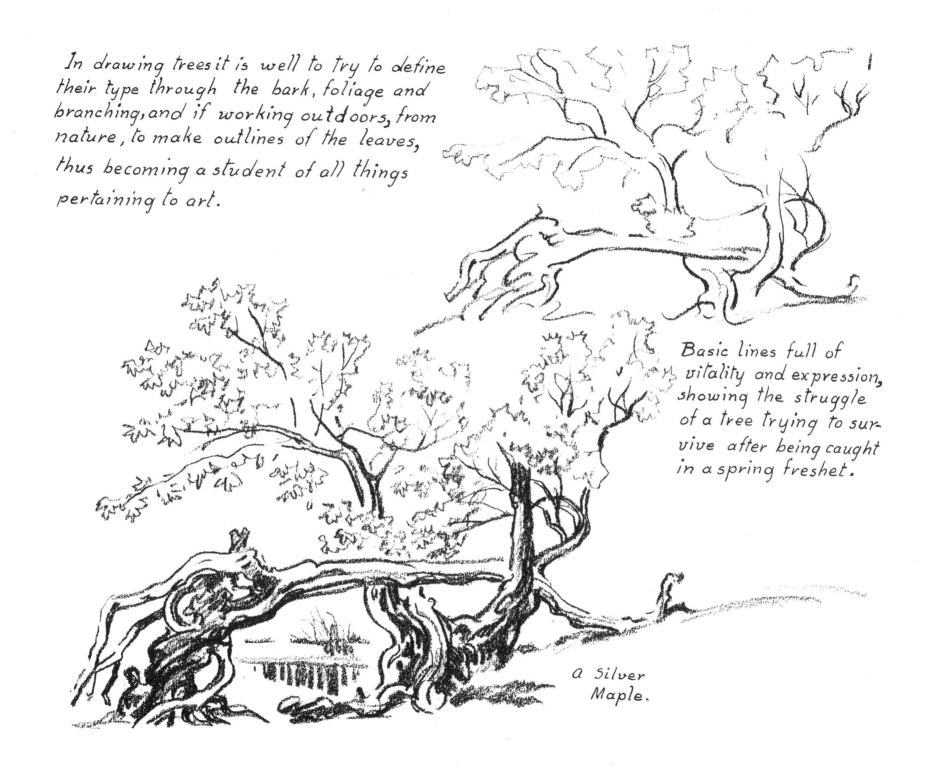

In drawing trees it is well to try to define their type through the bark, foliage and branching, and if working outdoors, from nature, to make outlines of the leaves, thus becoming a student of all things pertaining to art.

Basic lines full of vitality and expression, showing the struggle of a tree trying to survive after being caught in a spring freshet.

A Silver Maple.

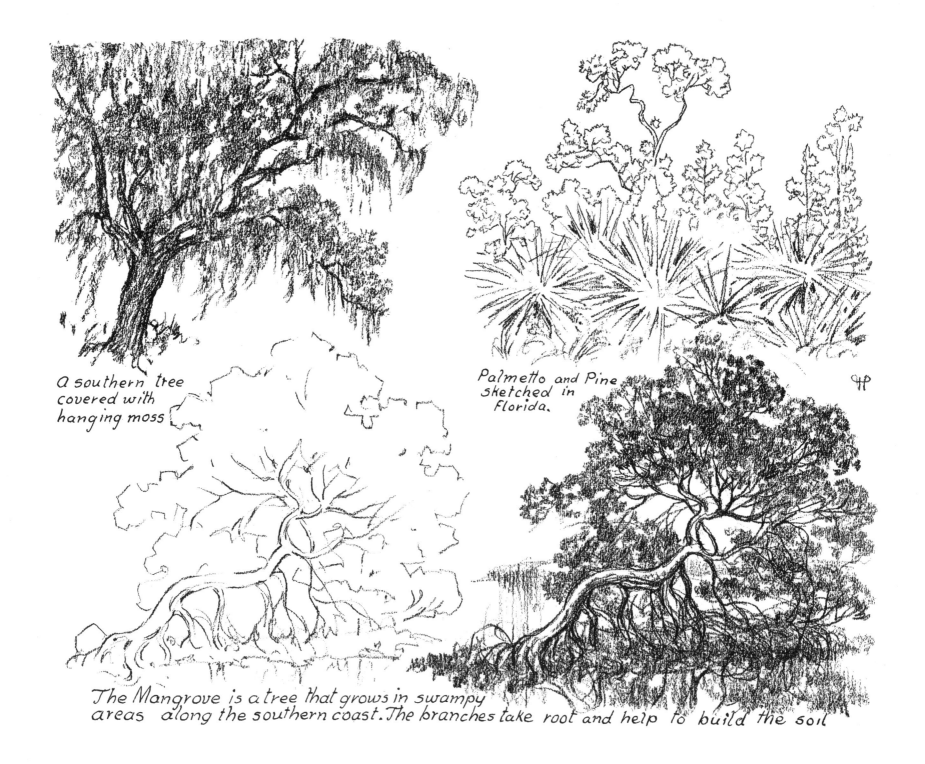

A southern tree covered with hanging moss

Palmetto and Pine sketched in Florida.

The Mangrove is a tree that grows in swampy areas along the southern coast. The branches take root and help to build the soil

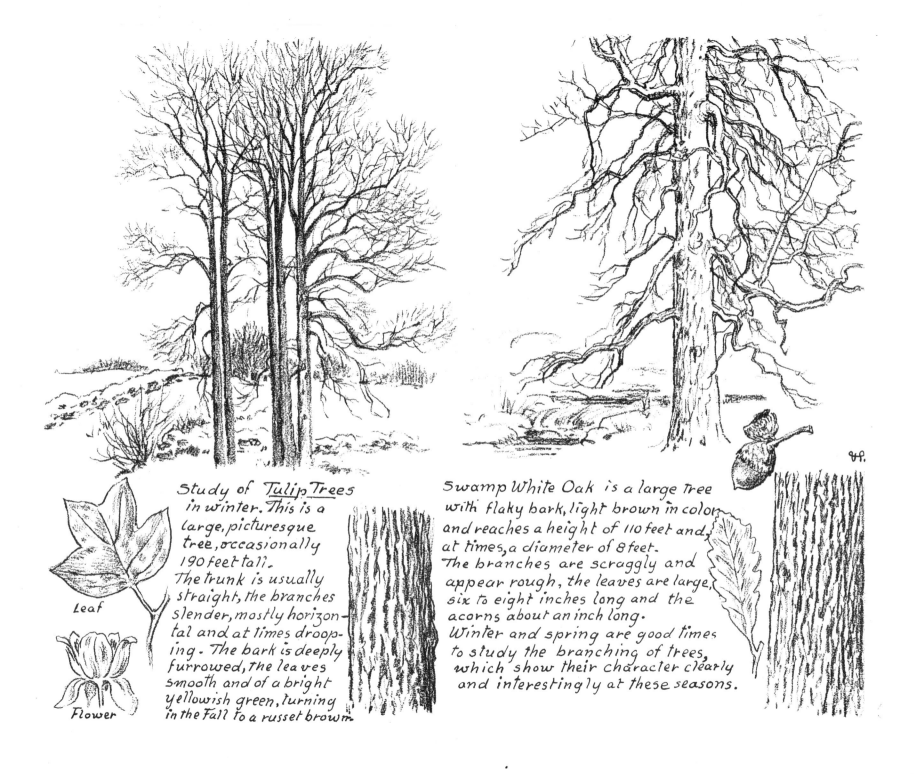

Leaf

Flower

Study of _Tulip Trees_ in winter. This is a large, picturesque tree, occasionally 190 feet tall.
The trunk is usually straight, the branches slender, mostly horizontal and at times drooping. The bark is deeply furrowed, the leaves smooth and of a bright yellowish green, turning in the Fall to a russet brown.

Swamp White Oak is a large tree with flaky bark, light brown in color, and reaches a height of 110 feet and, at times, a diameter of 8 feet.
The branches are scraggly and appear rough, the leaves are large, six to eight inches long and the acorns about an inch long.
Winter and spring are good times to study the branching of trees, which show their character clearly and interestingly at these seasons.

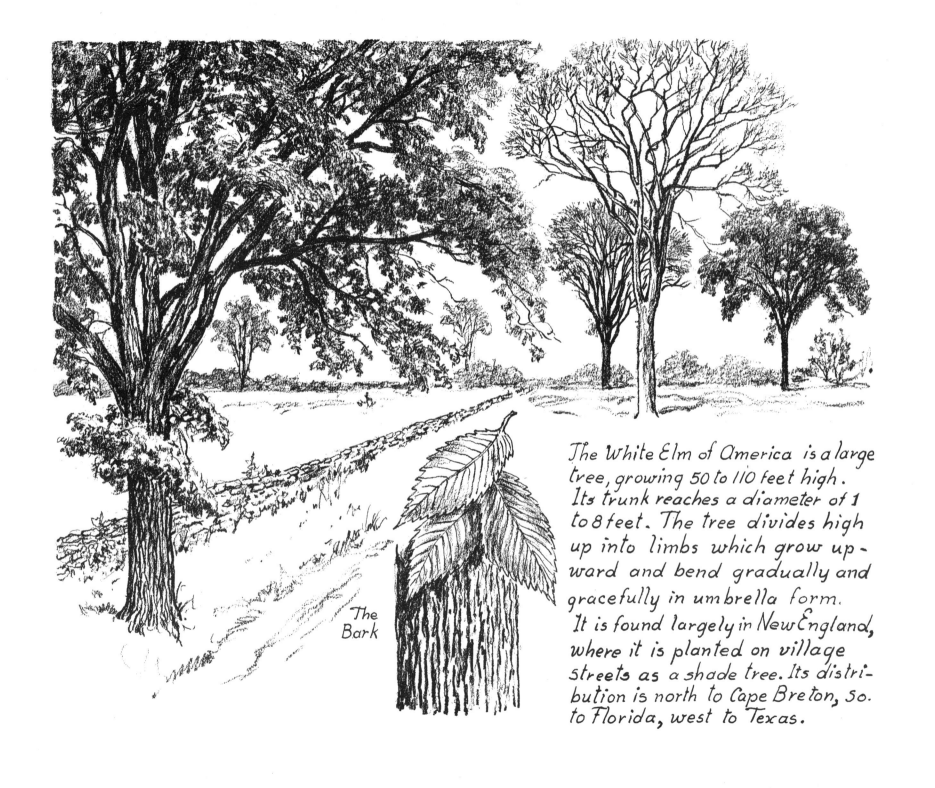

The Bark

The White Elm of America is a large tree, growing 50 to 110 feet high. Its trunk reaches a diameter of 1 to 8 feet. The tree divides high up into limbs which grow upward and bend gradually and gracefully in umbrella form.

It is found largely in New England, where it is planted on village streets as a shade tree. Its distribution is north to Cape Breton, So. to Florida, west to Texas.

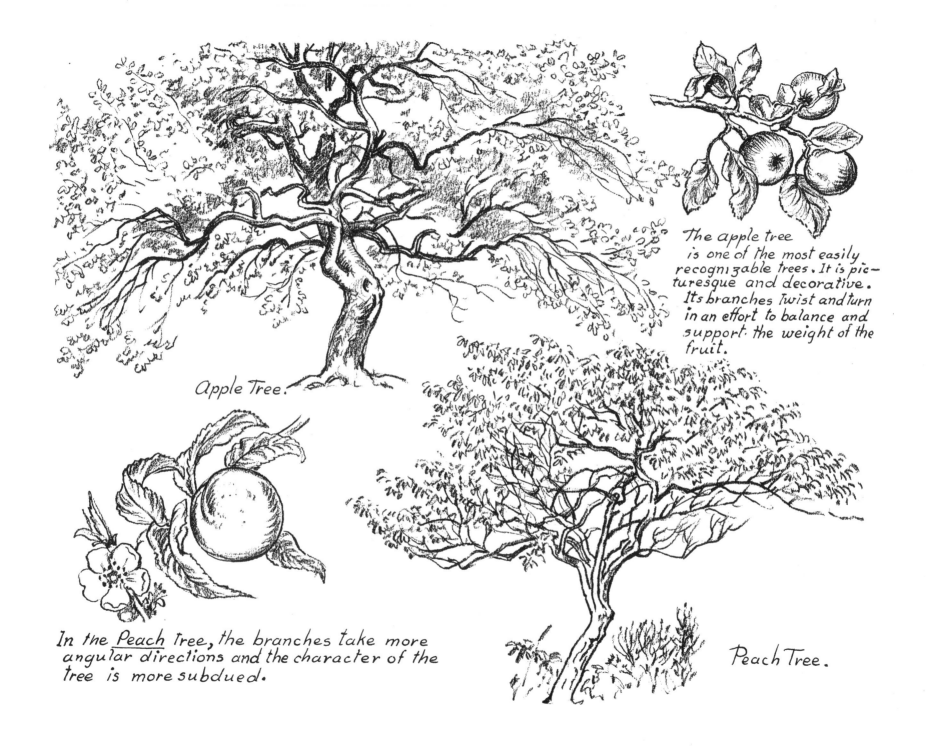

Apple Tree.

The apple tree is one of the most easily recognizable trees. It is picturesque and decorative. Its branches twist and turn in an effort to balance and support the weight of the fruit.

In the _Peach_ tree, the branches take more angular directions and the character of the tree is more subdued.

Peach Tree.

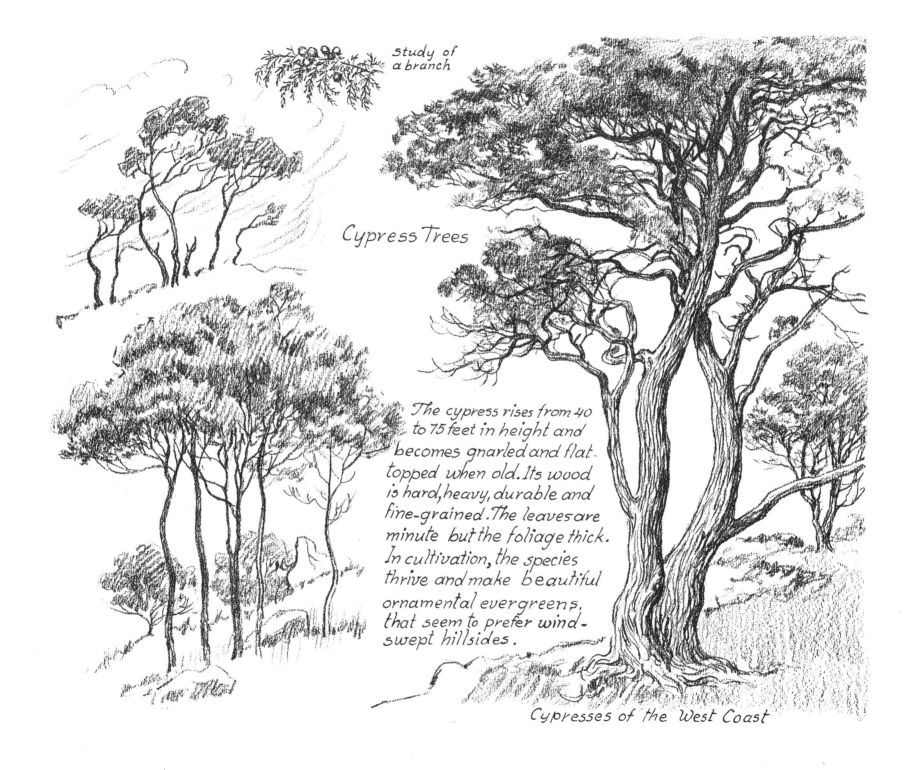

study of
a branch

Cypress Trees

The cypress rises from 40
to 75 feet in height and
becomes gnarled and flat-
topped when old. Its wood
is hard, heavy, durable and
fine-grained. The leaves are
minute but the foliage thick.
In cultivation, the species
thrive and make beautiful
ornamental evergreens.
that seem to prefer wind-
swept hillsides.

Cypresses of the West Coast

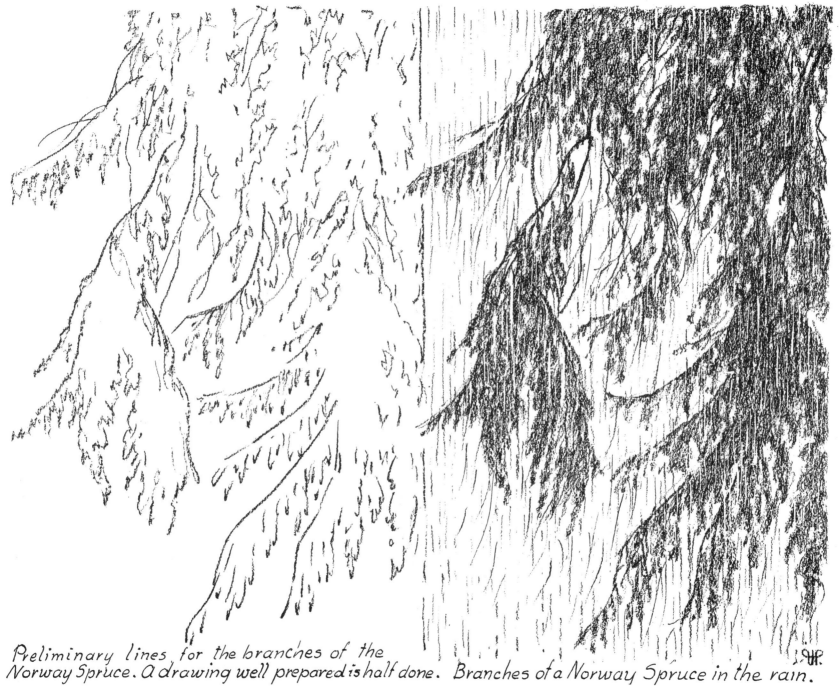

Preliminary lines for the branches of the Norway Spruce. A drawing well prepared is half done. Branches of a Norway Spruce in the rain.

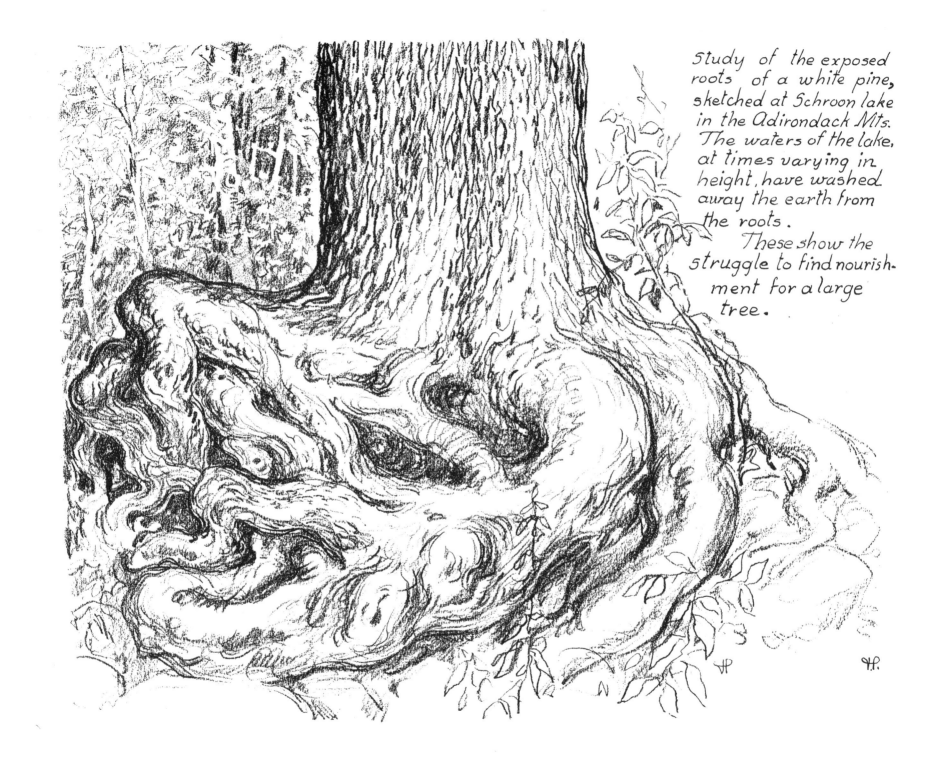

Study of the exposed roots of a white pine, sketched at Schroon lake in the Adirondack Mts. The waters of the lake, at times varying in height, have washed away the earth from the roots.

These show the struggle to find nourishment for a large tree.

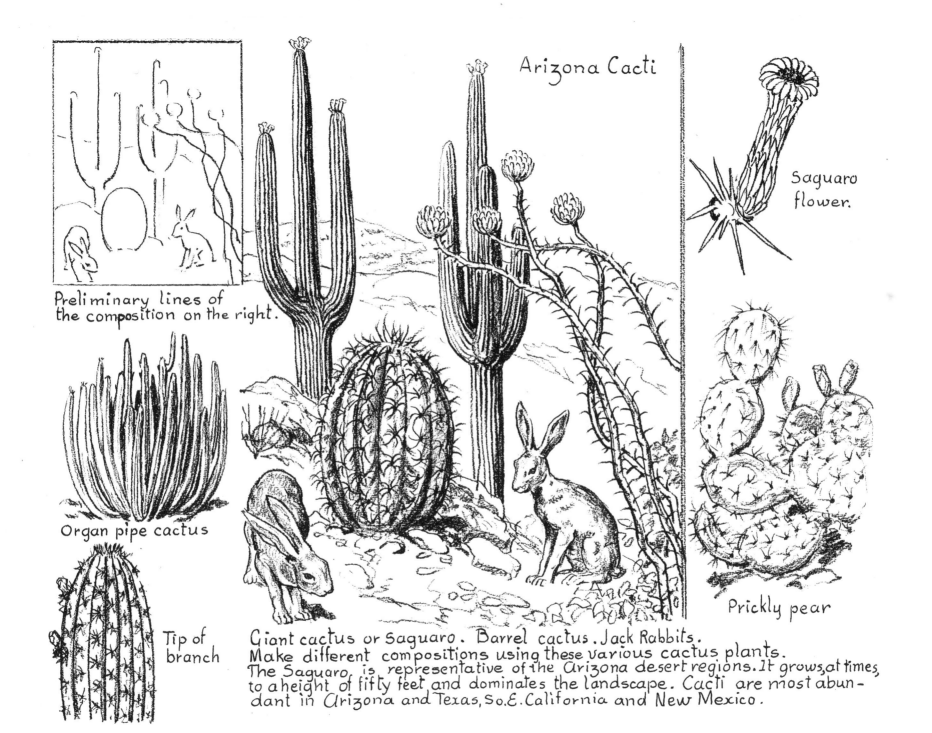

Arizona Cacti

Preliminary lines of
the composition on the right.

Saguaro
flower.

Organ pipe cactus

Tip of
branch

Prickly pear

Giant cactus or Saguaro. Barrel cactus. Jack Rabbits.
Make different compositions using these various cactus plants.
The Saguaro is representative of the Arizona desert regions. It grows, at times,
to a height of fifty feet and dominates the landscape. Cacti are most abun-
dant in Arizona and Texas, So.E. California and New Mexico.

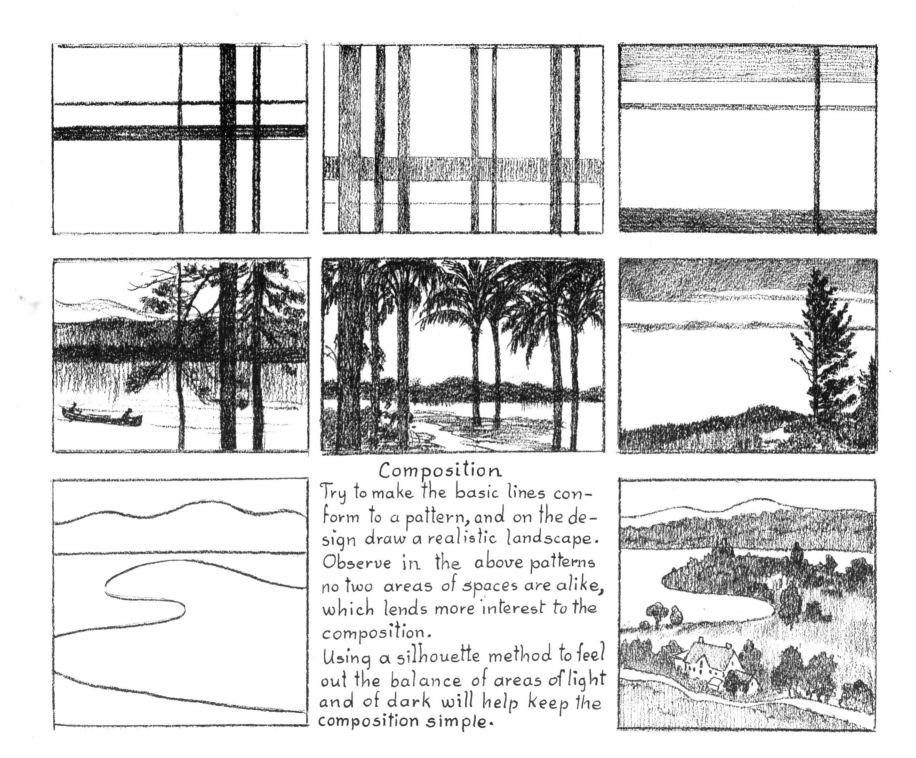

Composition

Try to make the basic lines conform to a pattern, and on the design draw a realistic landscape.

Observe in the above patterns no two areas of spaces are alike, which lends more interest to the composition.

Using a silhouette method to feel out the balance of areas of light and of dark will help keep the composition simple.

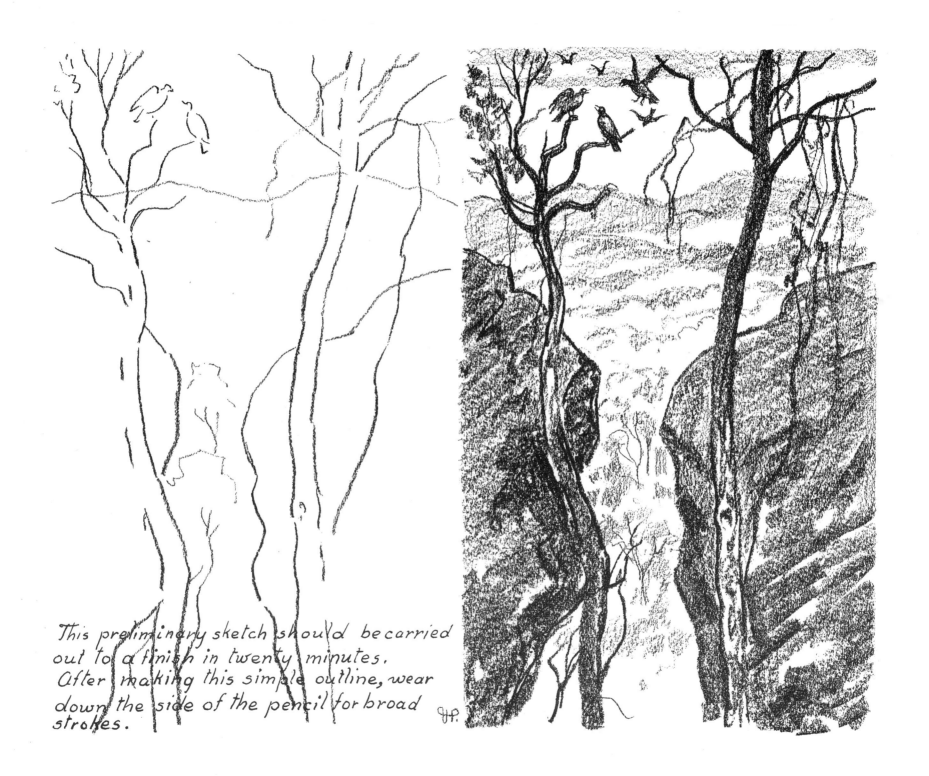

This preliminary sketch should be carried
out to a finish in twenty minutes.
After making this simple outline, wear
down the side of the pencil for broad
strokes.

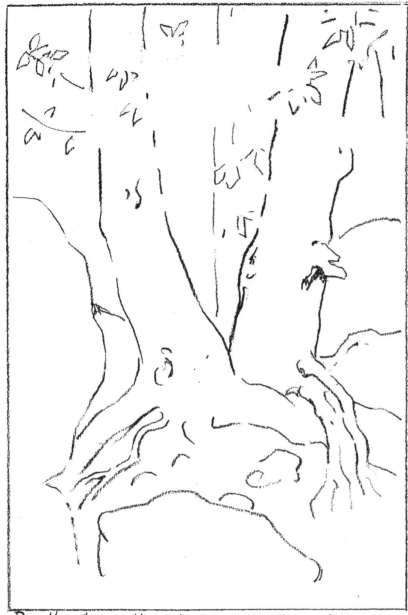

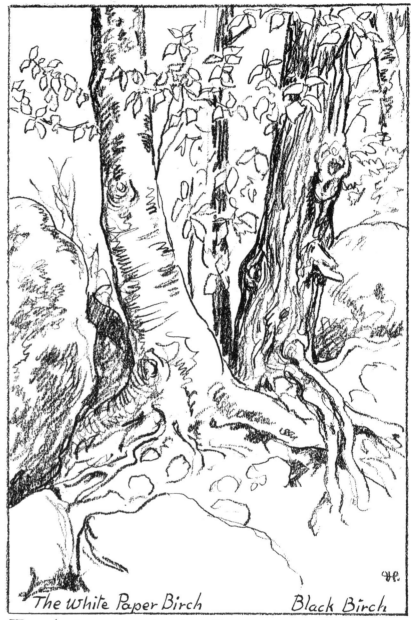

The White Paper Birch Black Birch

By the time the decision has been taken for
the placing of the principal lines in a compo-
sition, the mind is just about made up as
to the shading to be added.

The design made by the slanting trunks
and branching and twisting roots makes for
an interesting memorandum sketch.

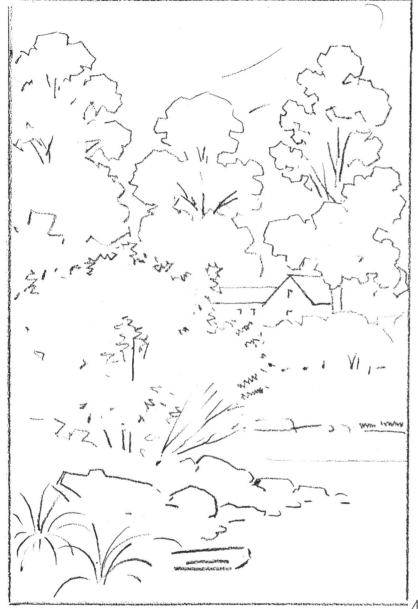

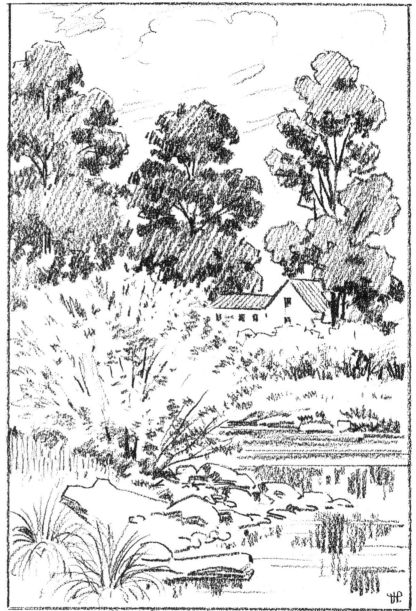

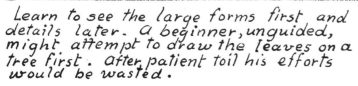

Pussy Willow ↑ Chestnut ↑ Poplar ↑

Learn to see the large forms first and details later. A beginner, unguided, might attempt to draw the leaves on a tree first. After patient toil his efforts would be wasted.

After the outline is drawn in, a few well-placed shadows will easily complete this picture.

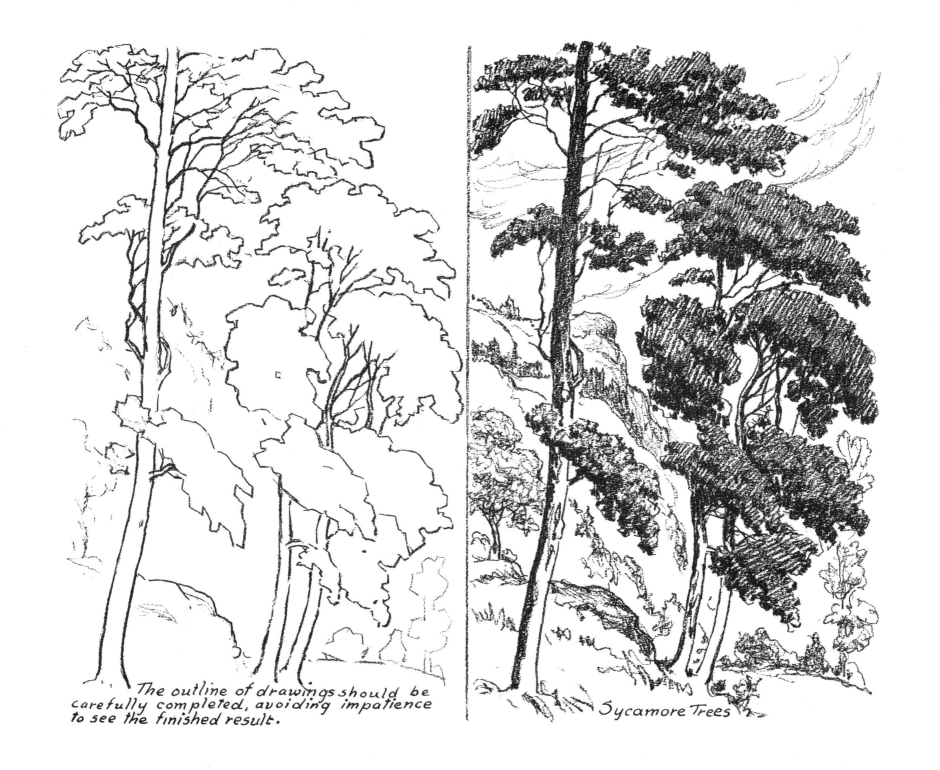

The outline of drawings should be carefully completed, avoiding impatience to see the finished result.

Sycamore Trees

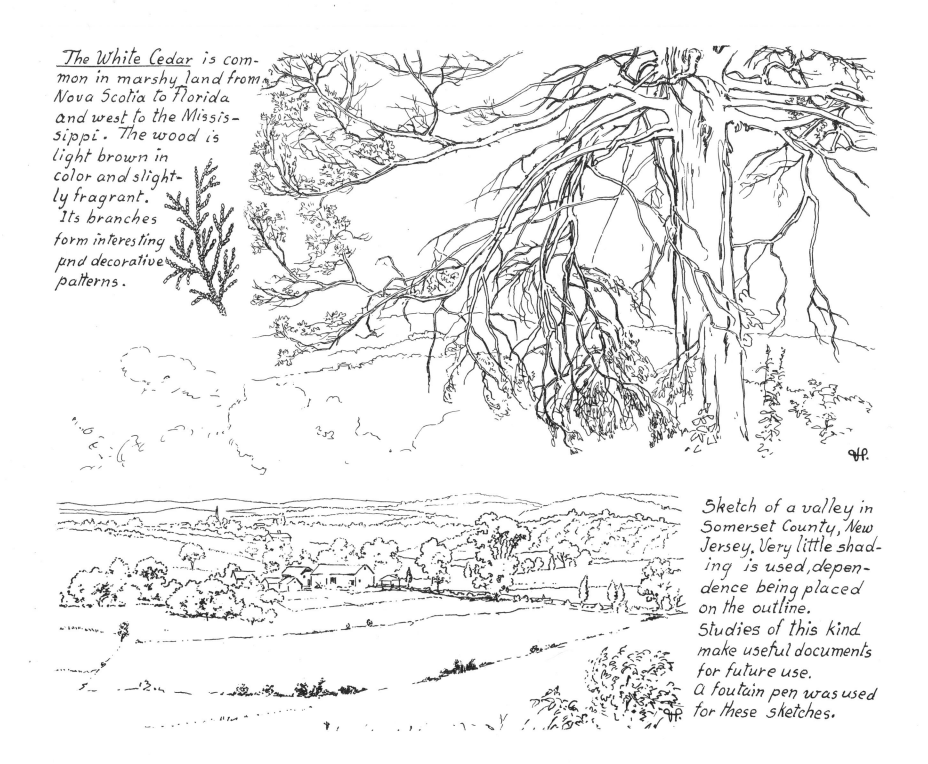

The White Cedar is common in marshy land from Nova Scotia to Florida and west to the Mississippi. The wood is light brown in color and slightly fragrant.
Its branches form interesting and decorative patterns.

Sketch of a valley in Somerset County, New Jersey. Very little shading is used, dependence being placed on the outline.
Studies of this kind make useful documents for future use.
A fountain pen was used for these sketches.

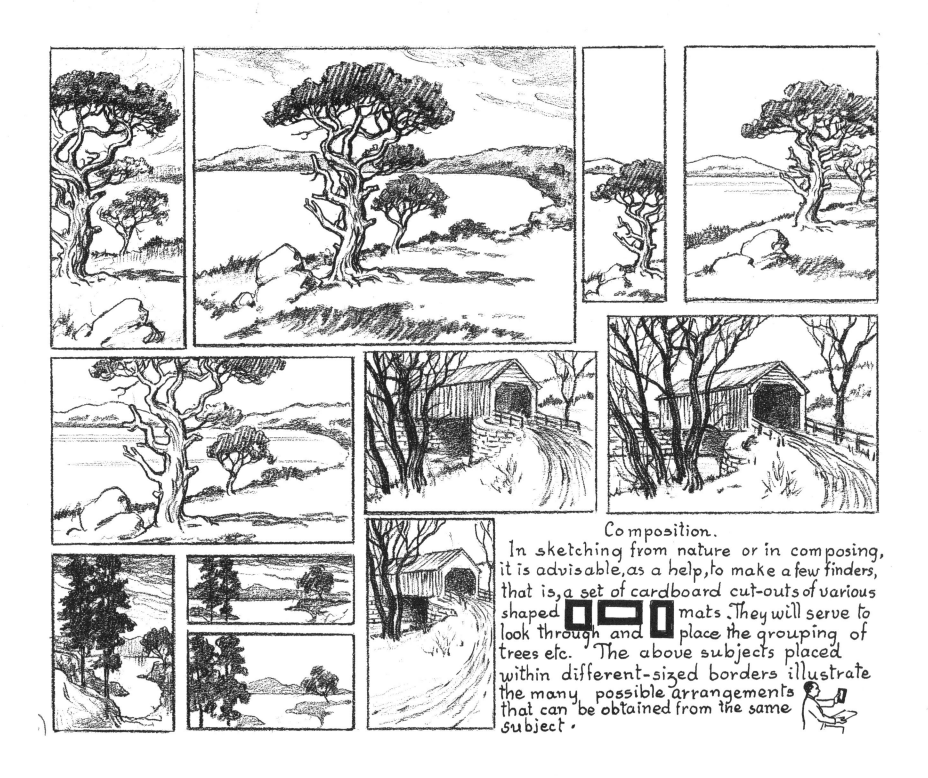

Composition.

In sketching from nature or in composing, it is advisable, as a help, to make a few finders, that is, a set of cardboard cut-outs of various shaped ▢ ▭ ▯ mats. They will serve to look through and ▯ place the grouping of trees etc. The above subjects placed within different-sized borders illustrate the many possible arrangements that can be obtained from the same subject.

Perspective

Perspective is the representation of the diminution of objects to the eye as they become more or less remote to the observer. It is an important and indispensable auxiliary to the artist. As a test take a ruler and measure a person forty feet away and as he approaches see how much larger he appears. This will show the difference in size of things remote or near.

When the eye is directed to any scene in nature it embraces no more than what most agreeably fills its power of vision without turning the head.

The picture would naturally be embraced by a circular limit. The point of sight is always within the picture because that is where the eye is placed.

The line of the horizon is always on a level with the eye of the observer.

Point of sight

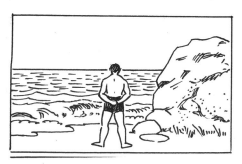 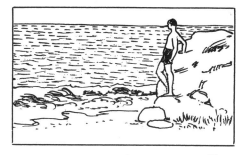 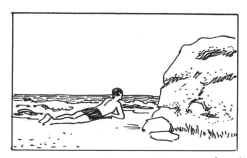

The horizon line is on the level with the eye.

The horizon line would have the curve of the earth but so little of it is seen at a time that it can be drawn straight.

The horizon line is still on a level with the observer's eye but, as he has climbed to a higher level, the line of the horizon is higher.

By assuming the onlooker's position, the horizon line is much lower to the eye, as illustrated above.

PERSPECTIVE

Looking through a window with square panes of glass would give upright lines and horizontal lines to help in seeing how much of an angle the lines would take to reach the point of sight. To this point of sight the lines that are parallel converge and terminate.

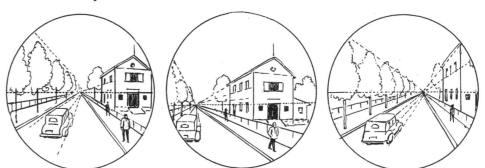

The point of sight need not always be in the center of the picture. It may suit the composition better to shift it to one side or the other on the horizon line to obtain a more pleasing arrangement.

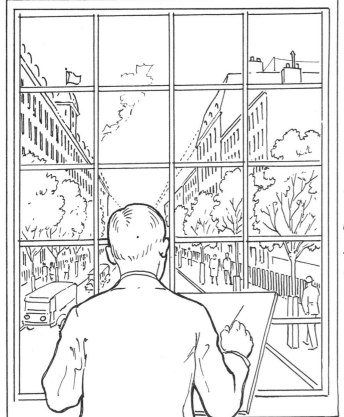

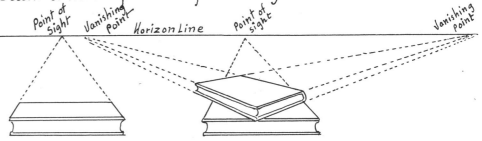

Aërial Perspective has reference more particularly to atmospheric conditions by which objects more or less remote are affected as to color, light, shadows and gradation of tints according to their distance.

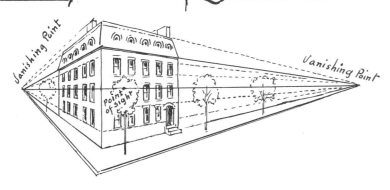

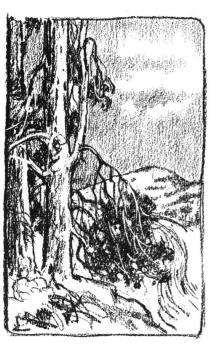
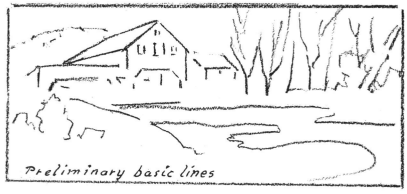

Preliminary basic lines

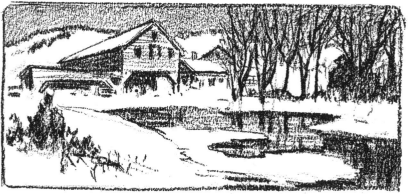

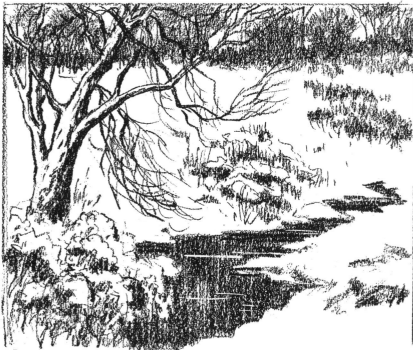

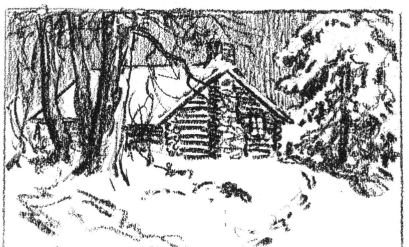

Small winter landscapes made boldly with a
soft pencil prove of great value and can be
quickly drawn.

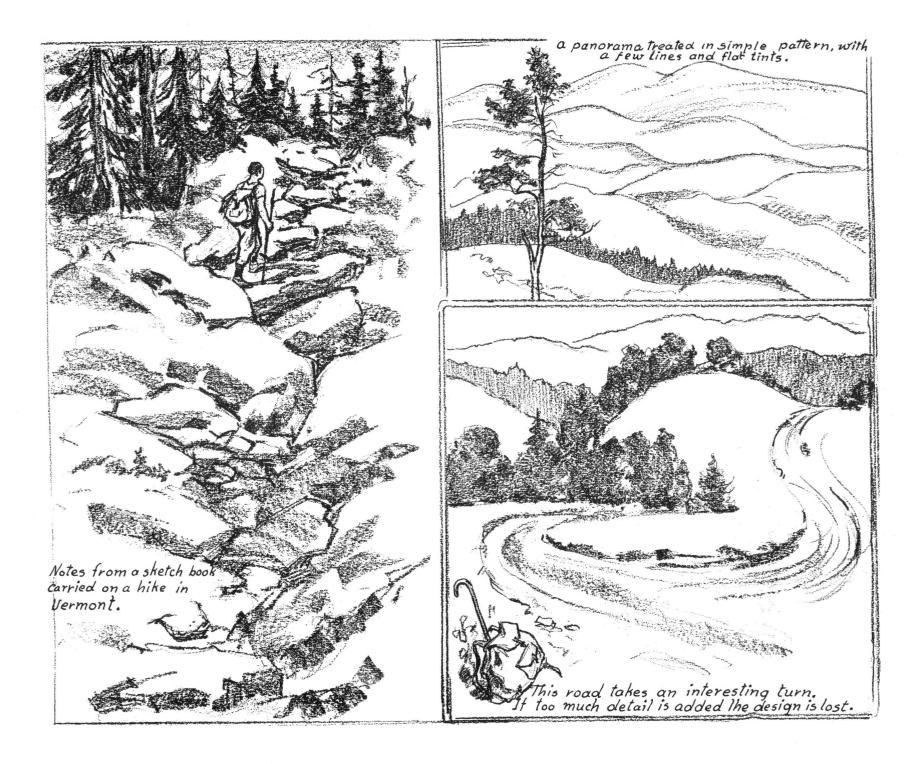

a panorama treated in simple pattern, with a few lines and flat tints.

Notes from a sketch book carried on a hike in Vermont.

This road takes an interesting turn. If too much detail is added the design is lost.

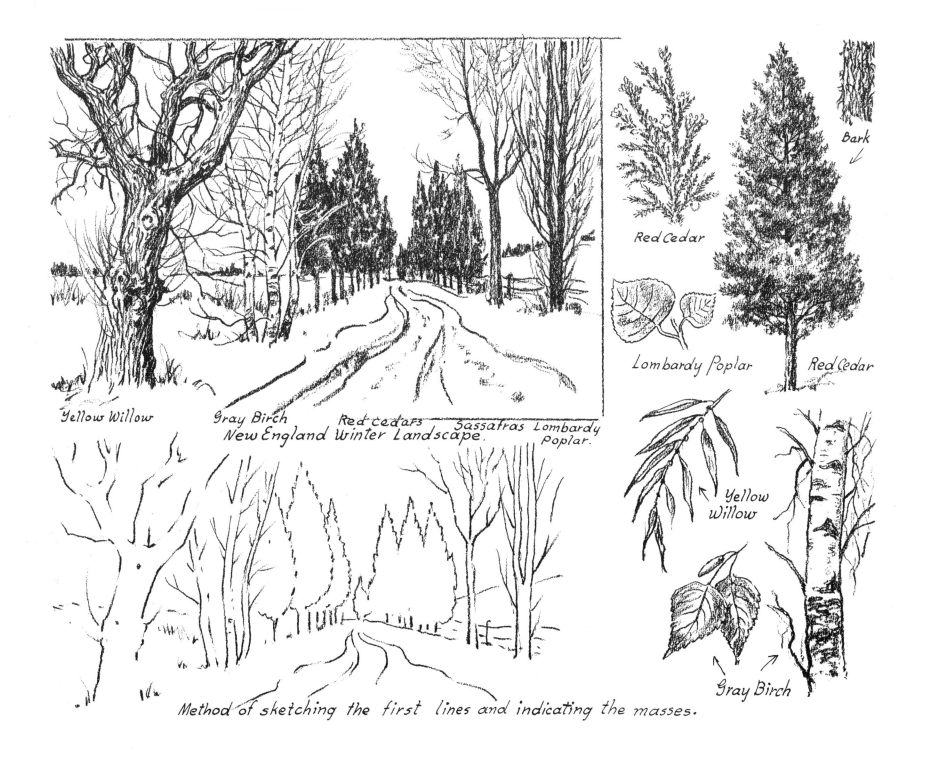

Yellow Willow Gray Birch Red Cedars Sassafras Lombardy

New England Winter Landscape. Poplar.

Red Cedar

Bark

Lombardy Poplar Red Cedar

Yellow Willow

Gray Birch

Method of sketching the first lines and indicating the masses.

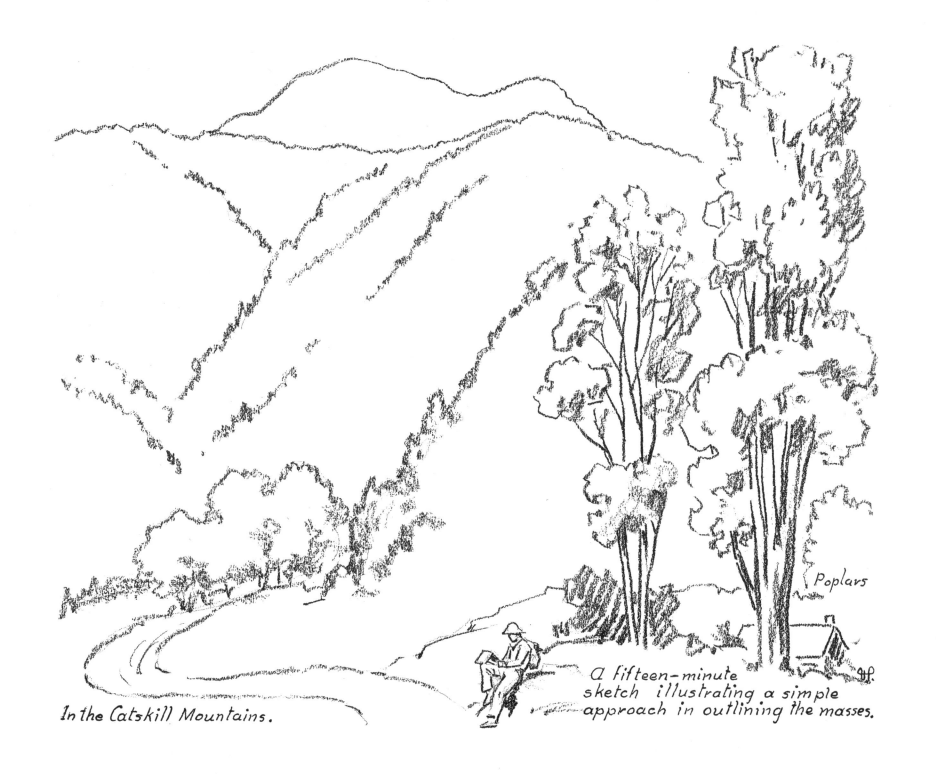

Poplars

In the Catskill Mountains.

A fifteen-minute
sketch illustrating a simple
approach in outlining the masses.

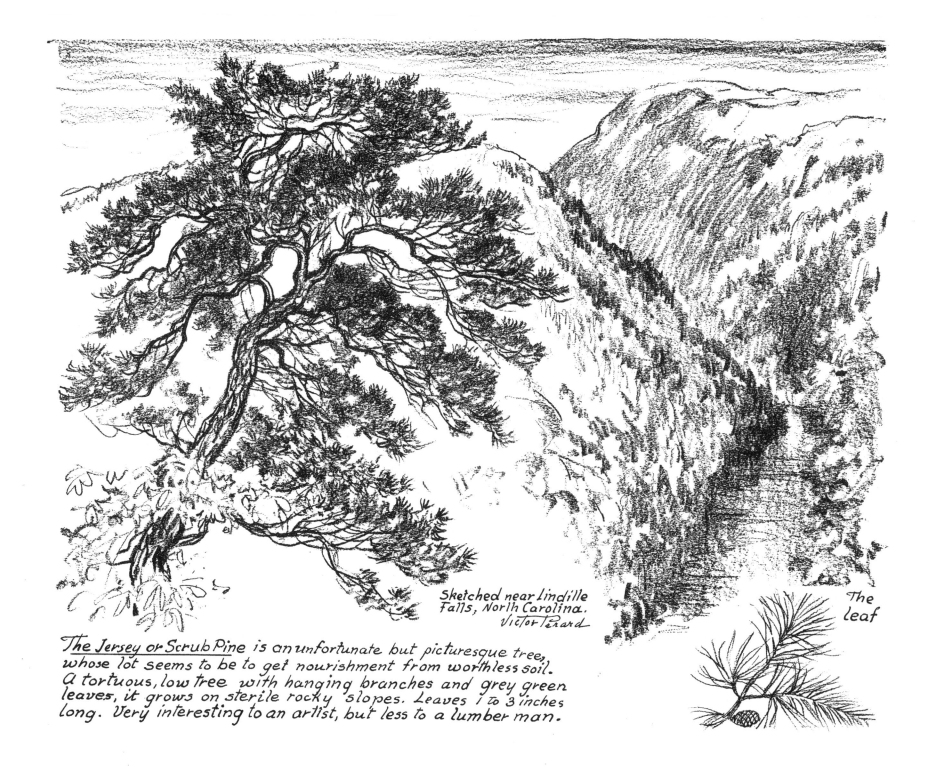

Sketched near Lindille
Falls, North Carolina.
Victor Perard

The leaf

<u>The Jersey or Scrub Pine</u> is an unfortunate but picturesque tree,
whose lot seems to be to get nourishment from worthless soil.
A tortuous, low tree with hanging branches and grey green
leaves, it grows on sterile rocky slopes. Leaves 1 to 3 inches
long. Very interesting to an artist, but less to a lumber man.

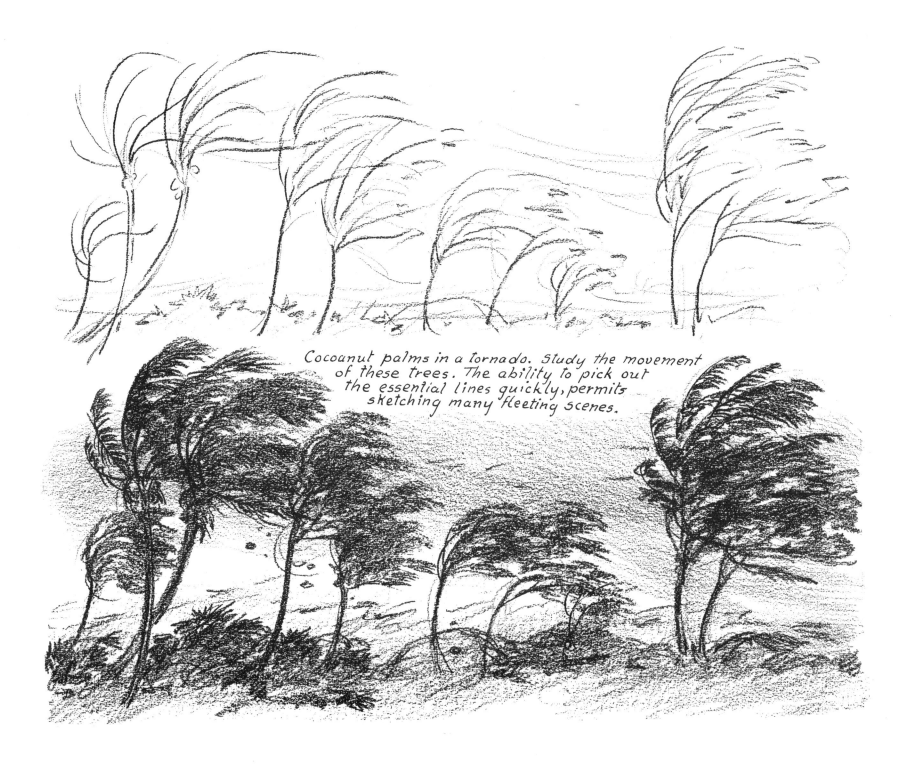

Cocoanut palms in a tornado. Study the movement of these trees. The ability to pick out the essential lines quickly, permits sketching many fleeting scenes.

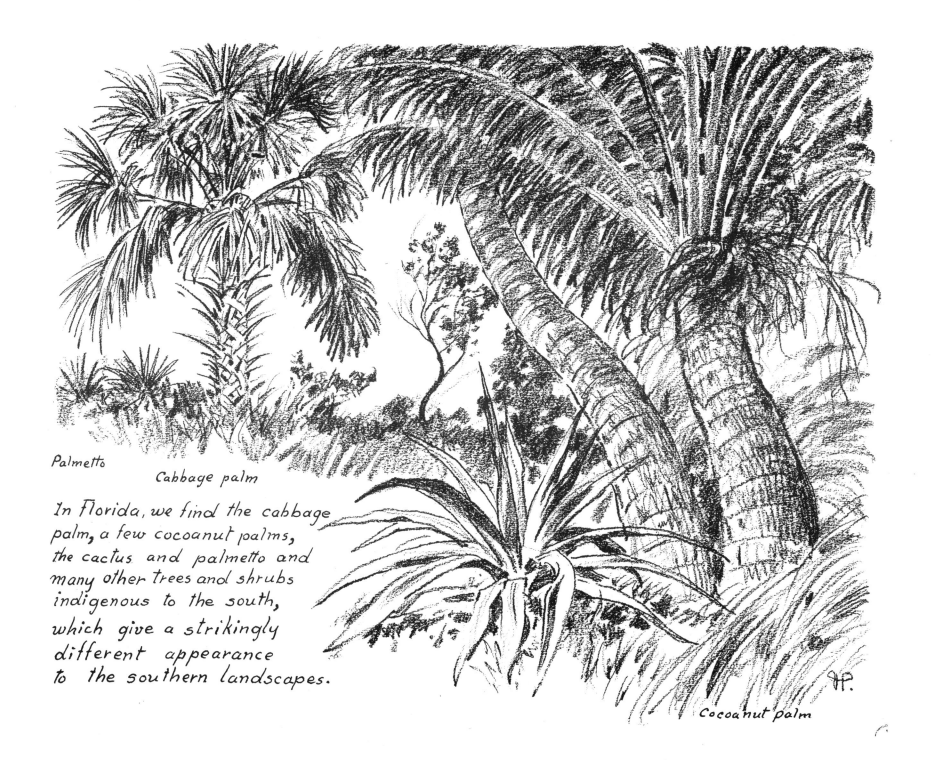

Palmetto

Cabbage palm

In Florida, we find the cabbage
palm, a few cocoanut palms,
the cactus and palmetto and
many other trees and shrubs
indigenous to the south,
which give a strikingly
different appearance
to the southern landscapes.

Cocoanut palm

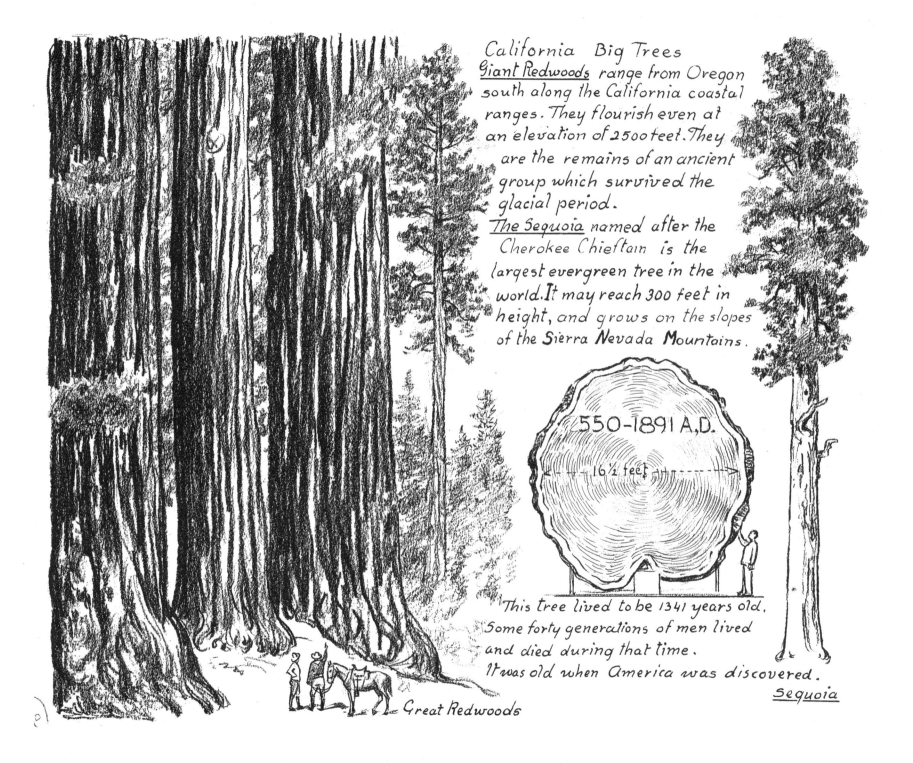

California Big Trees

Giant Redwoods range from Oregon south along the California coastal ranges. They flourish even at an elevation of 2500 feet. They are the remains of an ancient group which survived the glacial period.

The Sequoia named after the Cherokee Chieftain is the largest evergreen tree in the world. It may reach 300 feet in height, and grows on the slopes of the Sierra Nevada Mountains.

550-1891 A.D.

16½ feet

This tree lived to be 1341 years old. Some forty generations of men lived and died during that time. It was old when America was discovered.

Sequoia

Great Redwoods

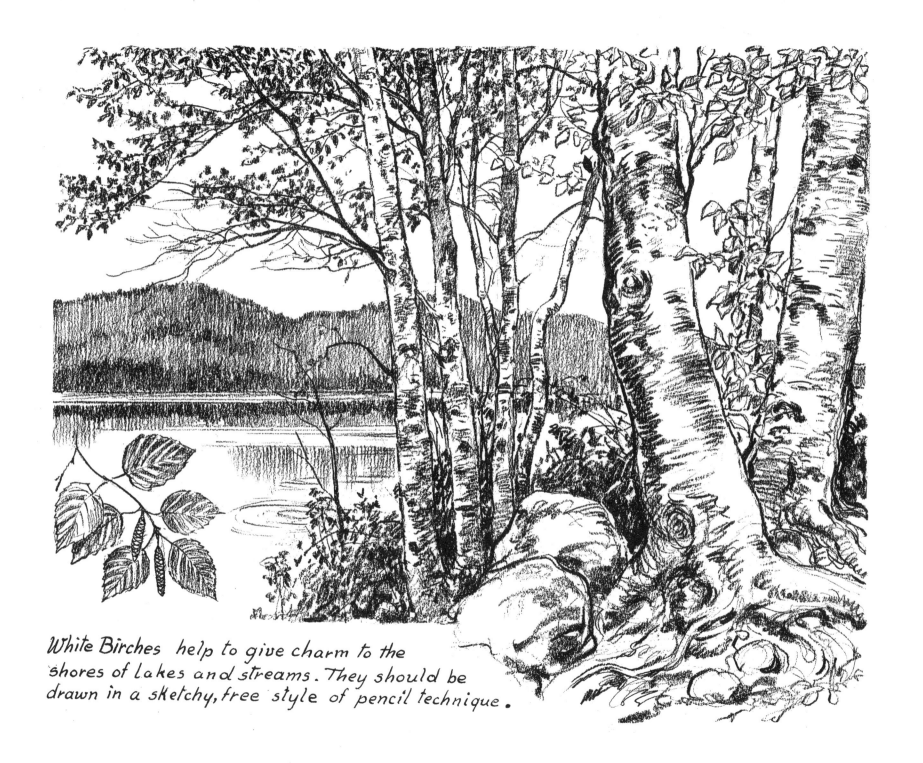

White Birches help to give charm to the
shores of lakes and streams. They should be
drawn in a sketchy, free style of pencil technique.

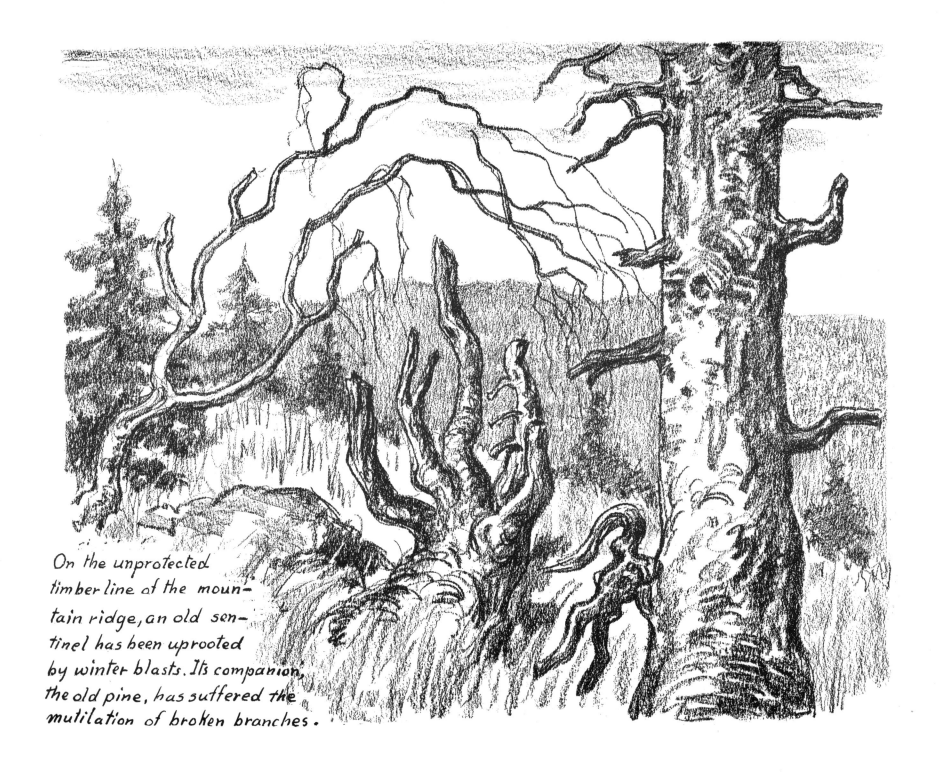

On the unprotected
timberline of the moun-
tain ridge, an old sen-
tinel has been uprooted
by winter blasts. Its companion,
the old pine, has suffered the
mutilation of broken branches.

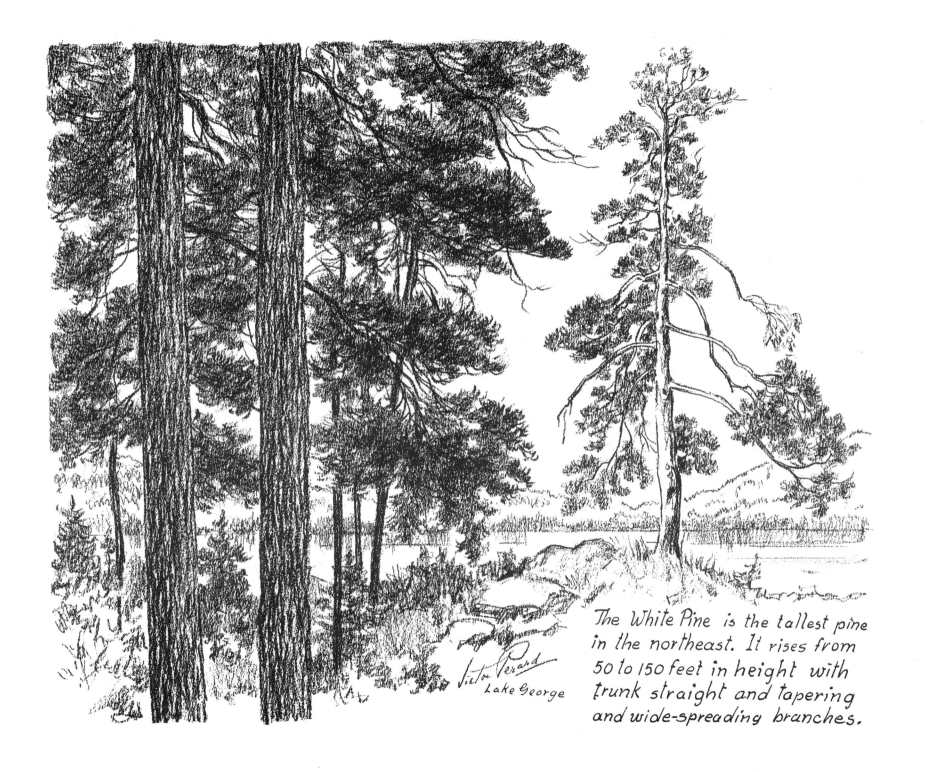

The White Pine is the tallest pine in the northeast. It rises from 50 to 150 feet in height with trunk straight and tapering and wide-spreading branches.

Lake George

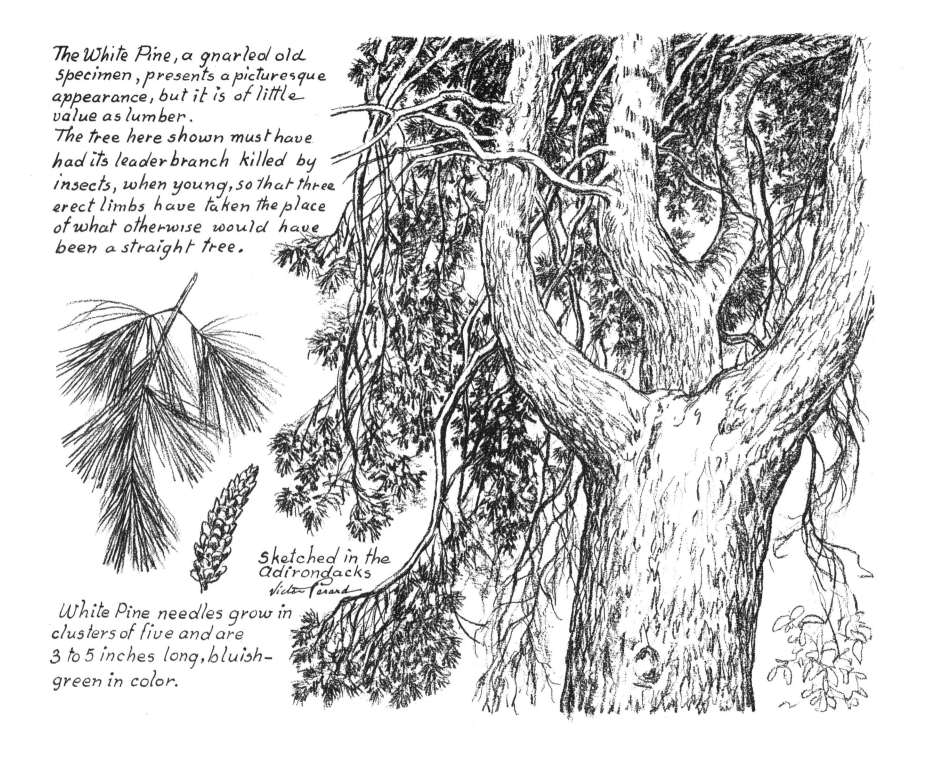

The White Pine, a gnarled old
Specimen, presents a picturesque
appearance, but it is of little
value as lumber.
The tree here shown must have
had its leader branch killed by
insects, when young, so that three
erect limbs have taken the place
of what otherwise would have
been a straight tree.

Sketched in the
Adirondacks
Victor Perard

White Pine needles grow in
clusters of five and are
3 to 5 inches long, bluish-
green in color.

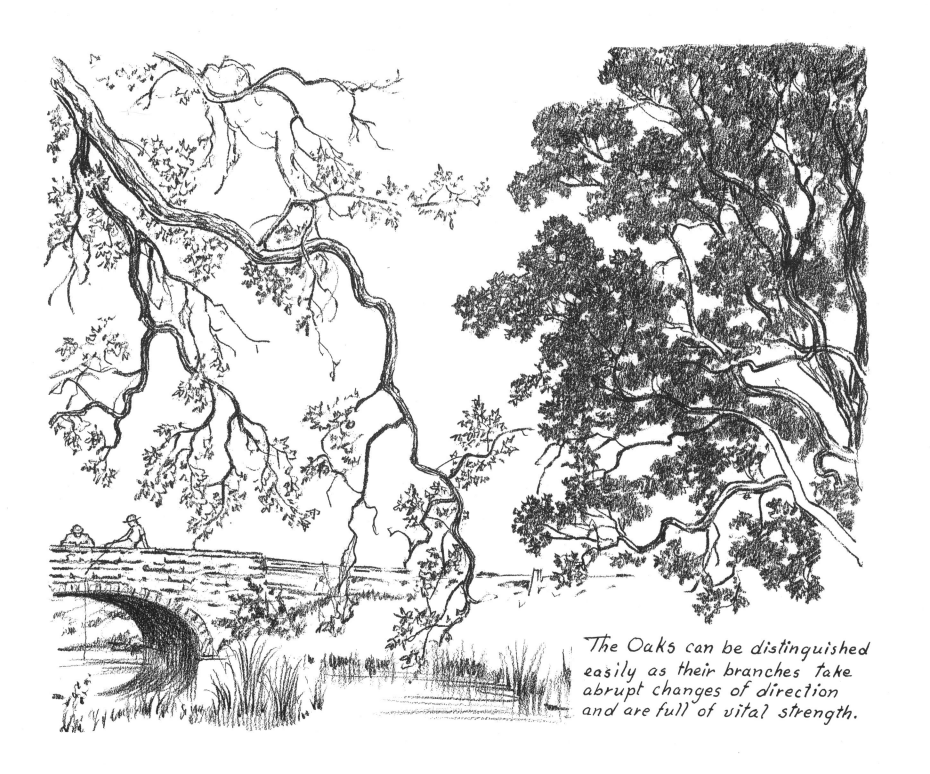

The Oaks can be distinguished
easily as their branches take
abrupt changes of direction
and are full of vital strength.

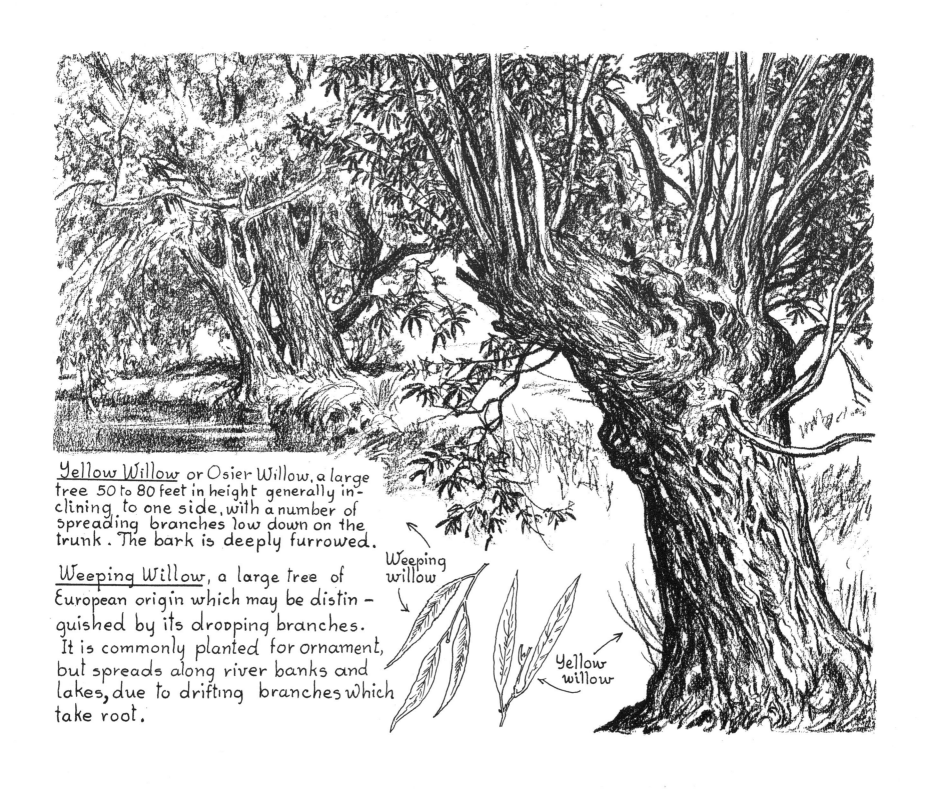

Yellow Willow or Osier Willow, a large tree 50 to 80 feet in height generally inclining to one side, with a number of spreading branches low down on the trunk. The bark is deeply furrowed.

Weeping Willow, a large tree of European origin which may be distinguished by its drooping branches. It is commonly planted for ornament, but spreads along river banks and lakes, due to drifting branches which take root.

Weeping willow

Yellow willow

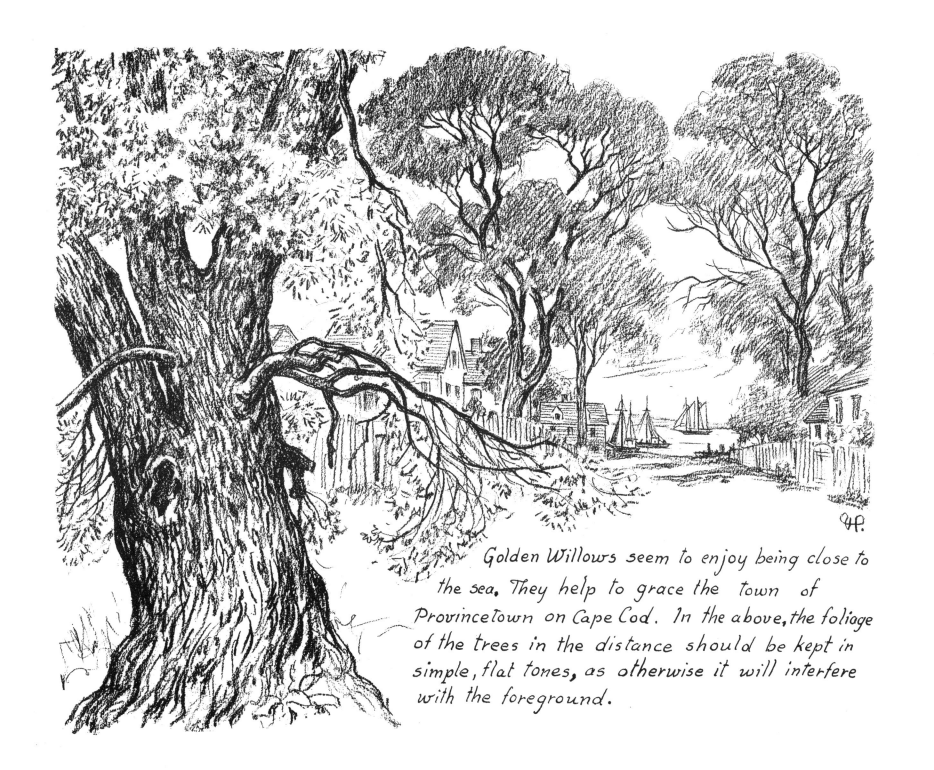

Golden Willows seem to enjoy being close to the sea. They help to grace the town of Provincetown on Cape Cod. In the above, the foliage of the trees in the distance should be kept in simple, flat tones, as otherwise it will interfere with the foreground.